To: _____

From: _____

My Heart Belongs to Dad

Appreciating Dad in Pictures and Words

A Picture Book for Grown-Ups

J.S. Salt

Copyright© 2002 by J.S. Salt
Additional Dialogue: Steve Bannos
Editor: Betty Bucksbaum

All rights reserved. No part of this book may be reproduced or transmitted in any form or by any means, electronic or mechanical, including photocopying, recording, or by any information storage and retrieval system, without permission in writing from the publisher.

Published by
Shake It! Books, LLC
P.O. Box 6565
Thousand Oaks, CA 91359
Toll Free (877) Shake It
www.*shake*that*brain*.com

Cover Photograph: © Ewing Galloway/Index Stock Imagery, Inc.

This book is available at special discounts for bulk purchase for sales promotions, premiums, fund-raising and educational use. Special books, or book excerpts, can also be created to fit specific needs. Got a need? We'll try to fill it.

Printed in Canada
ISBN: 1-931657-07-6
10 9 8 7 6 5 4 3 2 1

*To my Dad**

*See page 51.

Here's to Dad, my kind of guy.

"I sure like the sound of that!"

A man who'll give most anything a try.

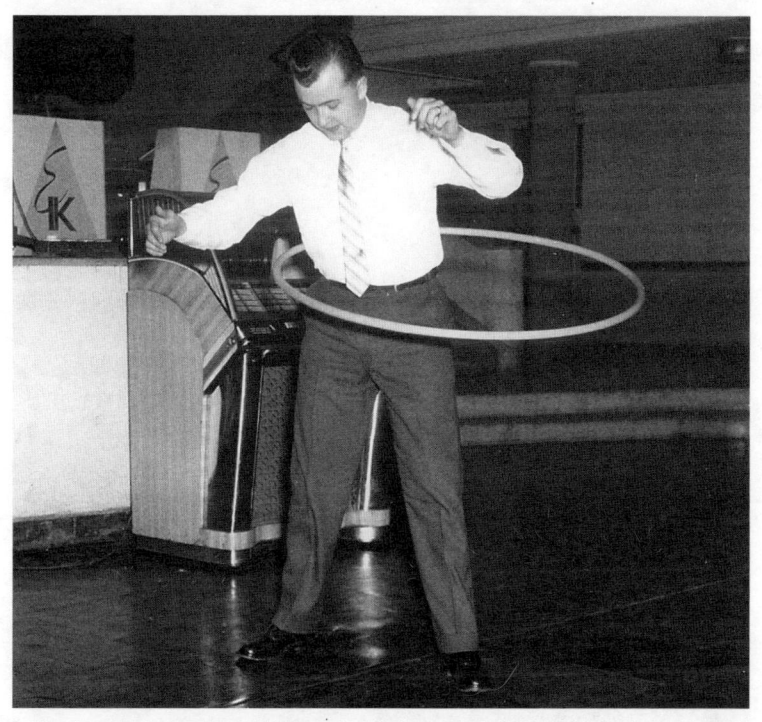

"And that's how I lost nineteen pounds in just seven hours."

(Even if sometimes it takes all day.)

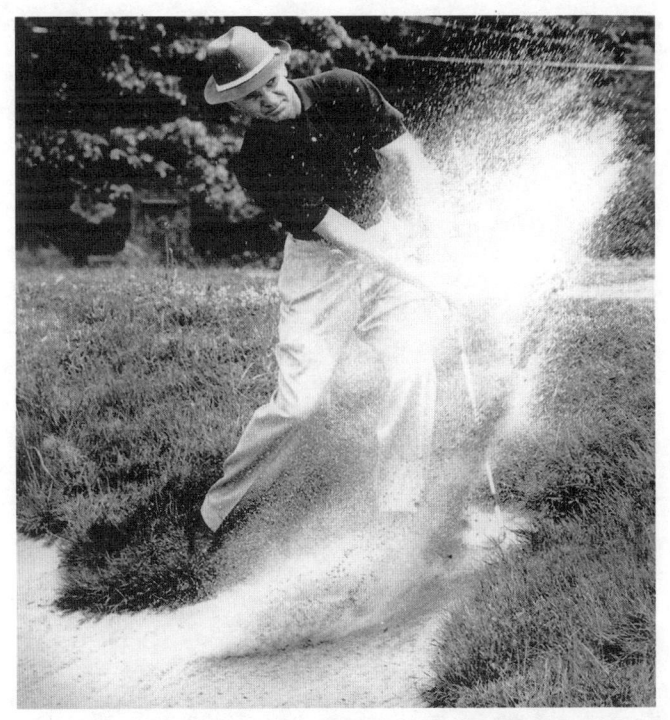

"Don't tell me there's not a ball down here!"

A man of pride…

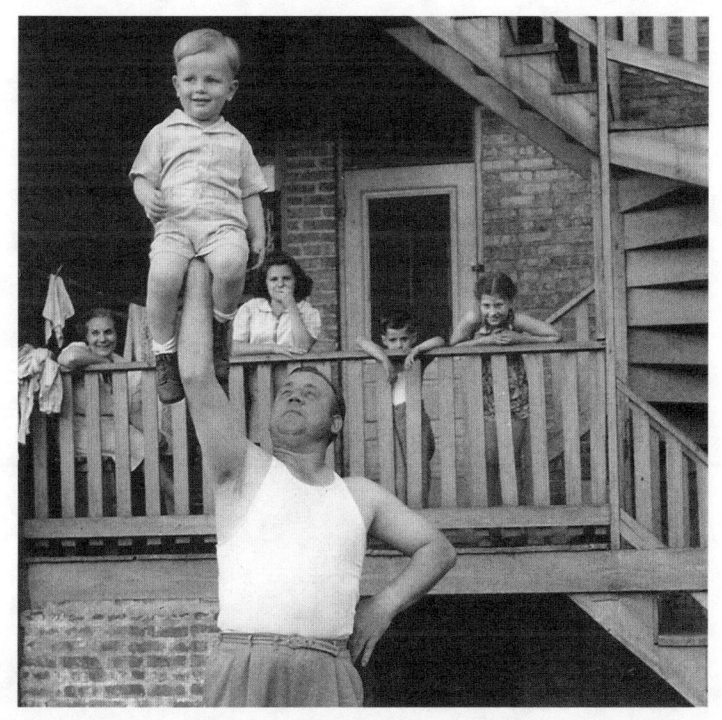

And a man of fun…

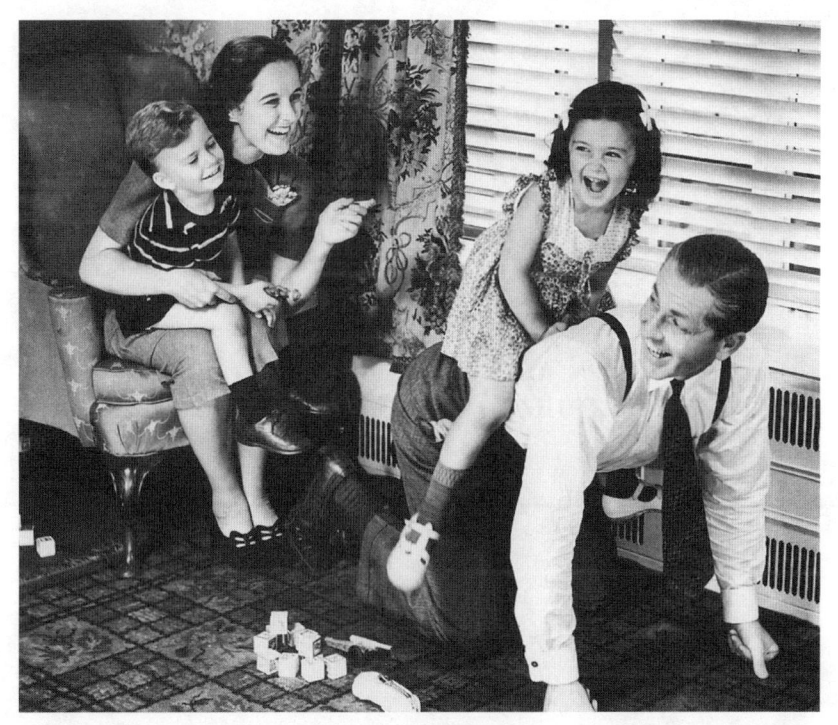

"Hi ho, Daddy-o!"

You're the man who gets things done!

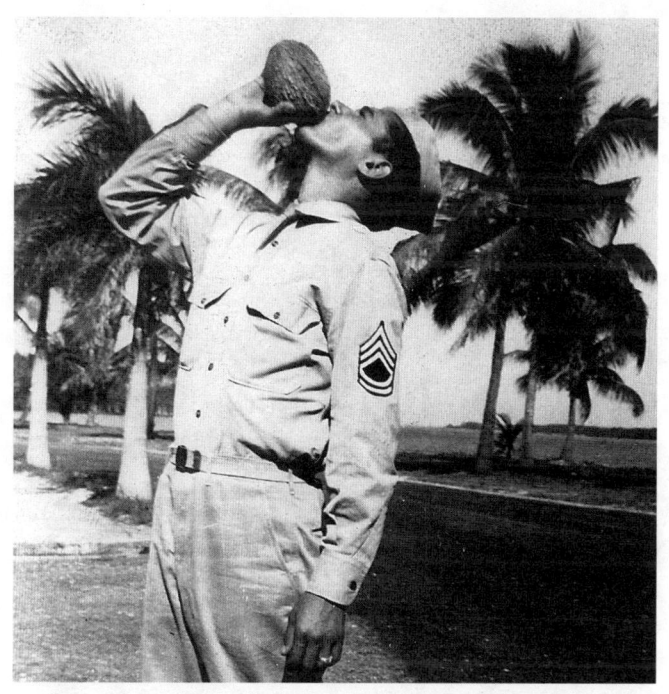

"So if at first that coconut won't crack…
find yourself an electric drill!"

Here's to Dad, a man of vision.

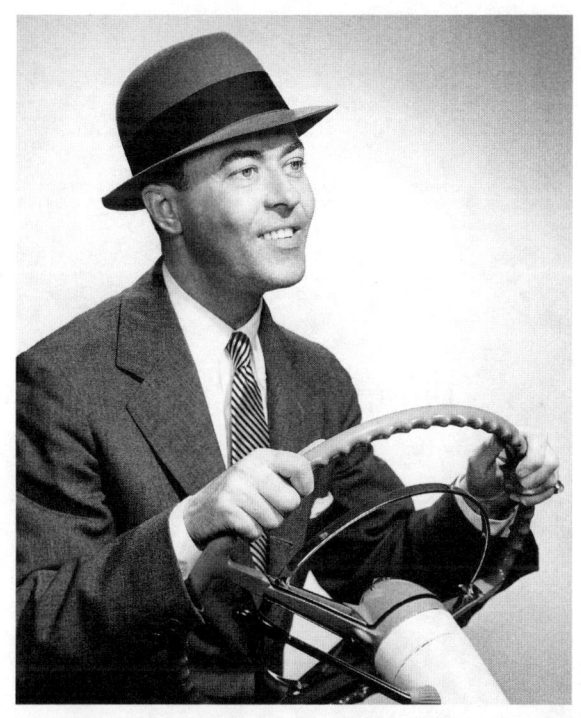

"No car? No road? No problem!"

You never let a bump in the road ruffle your cool.

"You did what!?!?"

No matter the problem, big or small,
you're always there to help me through.

As thoughtful today… …as you've always been!

You're always there to sympathize…

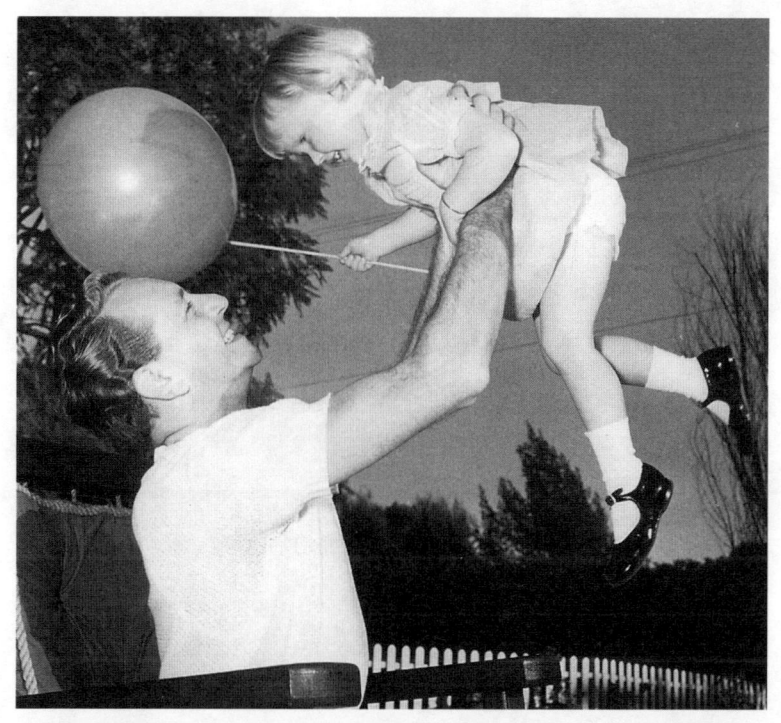

"I told you Dad would get you smiling again!"

And help me open my less seasoned eyes.

"I'm sorry, son. You just can't marry your teacher."

So thanks for spending the time we need…

"Then Sluggo says, *'I sure hope the tooth fairy finds me!'*"

And thanks for those chats you *think* we need.

"So never a lender nor borrower be and…
Gee, that's all I can think of right now."

Thanks, as well, for telling me
about when you were a kid,
and all those crazy things you did.

"I don't care if he *is* my son. We need to teach this boy a lesson!"

Here's to Dad, full of energy and zest.
From showing me how to pass any test…

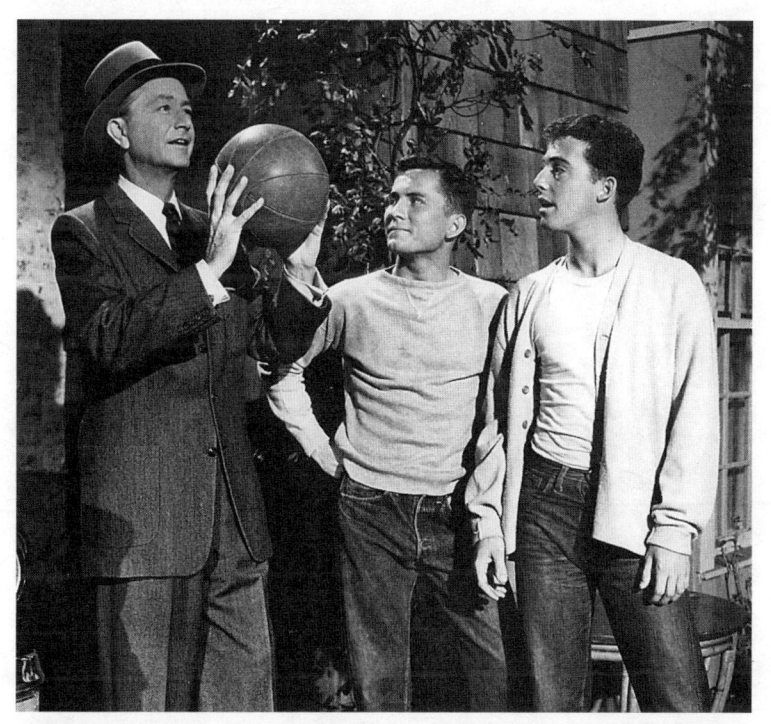

"Just focus on the basket and wear a good suit."

To winding me up when I need my rest.

"Okay, okay, we'll go to bed.
But first you have to catch us!"

And should there be a fright
from things that go bump in the night,
count on Dad to make things right!

"I'm warning you, Mr. Monster.
Come out of that closet or you're toast!"

That's why Dad is a hero to me.

"Air Marshall Dad. At your service!"

You know when to be quiet…

"Whatever you do… don't wake your mother."

And when to be loud.

"*Last one in the tub is a rotten egg!*"

You know when to pick up the pace…

"7:59? Of course I'll make it in by eight!"

And when it's time to slow down a bit.

"Hey, Dad! How's the lawn mowing going?"

You know when to stay real close…

"See? He's the one who's scared of you!"

And when it's time to let things coast.

"Looks like Dad is giving himself a time out."

*H*ere's to Dad, for all you do.
From bringing home the bacon…

"Here it is!"

"…And there it goes!"

To making time for those family trips,
being sure to explain the rules of the road.

DAD'S GENERAL WARNING:
No hitting, no biting, no kicking, no screaming and no throwing up. And remember: Soon as someone says, "Are we there yet?," I'm turning this baby around!

And thanks so much for teaching me
to love and respect the great outdoors.
From leaving our campsite
cleaner than we found it…

"I'm an old cowhand… and a camping fan!"

To learning to love all God's friendly critters.

"*You're* leading? I thought *I* was leading!"

*H*ere's to Dad!
A man who's not afraid
to tackle any job.

"See? The crankshaft's connected to the shin bone and the motor goes... *Say, where is the motor?*"

(Even if sometimes it's not the best call.)

"Yep, looks like Dad blew up the car again!"

After all, you're a man
who juggles a lot of different jobs:

"Think someone could get that phone for me?"

From working hard around the house…

"Here's another fine mess I've painted myself into."

To pitching in around the yard.

"So take a tip from Cowboy Dad
and never forget to dress for success!"

You do the stuff that needs to be done…

"Sure it's a dirty job. But we gotta do it!"

And you make sure the game gets won.

"Just 27 outs to go and this game is mine!"

So when business keeps you working late,
or traveling out of town,
thanks so much for calling to say…

"...I wish I were home with you!"

"That's okay, I understand."

Then Dad comes home and it's a bright new day.
'Cause absence makes the heart grow fonder…

...And presents from Dad help a whole lot, too!

Here's to Dad! You show the way.
From having fun while keeping in shape…

"It's a bird... It's a plane... It's Jack LaLane!"

To teaching the value of
keeping your eye on the ball.

"I see it! I see it!
...I see it landing right next to that cow."

From helping out in the kitchen…

"See? We even have a size for you!"

To cleaning up the mess…

"Well, gee, it didn't *look* that tough."

No matter the job, you sure try your best.

"I'll make this baby sing if it's the last thing I do!"

*H*ere's to Dad, a man who meets
every challenge head on.
No matter how big…

"Trust me, it's a shortcut."

Or how routine.

"Look everyone, I didn't burn down the house this year!"

You teach me to have no fear…

"See? Dad's not afraid to make a fool of himself!"

While spreading good cheer all through the year.

*"My heart belongs to my fam-i-ly…
Here we are, so hap-pi-ly!"*

That's why Dad is Number One.

*"Dad's number one – Hey!
Dad's number one – Hey!"*

So thanks for the singing…

"Daddy, what does E-I-E-I-O mean?"

And thanks for the walks.

"We are fam-i-ly... All my cowpokes and me!"

It means so much to spend time with you.

"This is our Dad. He has four heads."

And thanks for making sure
we take those pictures now and then.

"Sure I know how to work this thing!"

From times we're really into it…

"This is us and we're lookin' good!"

To times we need to be coaxed a bit.

"C'mon, kids. Make your dad happy."

Thanks for the tenderness…

113

Thanks for the fun…

And thanks for the lift when I needed one.

"Next stop? Olympic Gold!"

Thanks for the teaching…

Thanks for believing…

121

And most of all…

...Thanks for the love.

For all you do and all you are,
thanks for being Dad!

"Hear that fella? I'm feelin' mighty appreciated!"

More "Picture Books for Grown-Ups"

My Heart Belongs to Mom

Boys Will Be Boys

Girls Will Be Girls

Fairy Tales Can Come True

Also By J.S. Salt

How To Be The Almost Perfect Husband:
By Wives Who Know

How To Be The Almost Perfect Wife:
By Husbands Who Know

What The World Needs Now:
Kids' Advice on Treating People Right